DRAWING FOR BEGINNERS

All You Need To Know About Drawing

By

John Pearson

Copyright 2016

CONTENTS

INTRODUCTION

CHAPTER 1
TOOLS AND EQUIPMENTS……………………………..1

Chapter 2
Have The Know How Of Light And Shadow…………..……6

CHAPTER 3
BREAKING OBJECTS TO BASE SHAPES………..…..…10

CHAPTER 4
DRAWING TECHNIQUES………………...…...……13

CHAPTER 5
SHADING AND GRADIENTS…………………..……19

CONCLUSION

Introduction

For many who admire the art of drawing, this is the right book for you to get acquainted with step by step guidelines throughout the whole journey of drawing. Many people who ventures in the art of drawing wishes to execute every single projects well and perfectly, and if it is a goal that you have ever set for yourself, then you've picked up the right book. Using the given techniques in this book, you will learn variety tricks and there is no way you could fail at achieving whatever goals you have for yourself when it comes to drawing like a real professional. It's not the end of things though, and if you are always willing and able to improve yourself and continue learning more about how to perfect your craft, there is nothing on earth that can stop you from achieving your goals.

A person with a real passion and urge for drawing doesn't require expensive items and materials to get started. Using simple and well suited tools for the projects can really do wonders. With only a few basic tools and materials, a vast range of techniques and effects are open to you. This book aims to introduce different ways of thinking about commonplace materials, through which you will become familiar with their various properties and gain proficiency in using them.

This is a simple guide to help anybody who is interested in art to learn how they can go from beginner quality to professional quality drawing. This book will help you to experience all the ups and downs of art. Most of us have a hard time getting started at something new, but with these beginners' tips and tricks, you will be able to bypass much of the difficulties that other people have when pursuing the arts and give

yourself the opportunity to truly thrive in your craft.

For those novices who have yet to become confident and professional in their art of drawing, there are some reminders of the basic principles of drawing. Discussions of best tools to use, drawing exercises, line, tone, perspective and more will include helpful tips and techniques that may also be useful to more accomplished artists.

Great artists need a grounding that they can build on to acquire self-actualization. Coupled with determination and impetus, achieving immeasurable success is inevitable. Being unique and innovative is a start, but there is more to it. Perhaps the most important trait an artist should have is a creative mind.

As times change, so does trends. In that case, a good artist should be able to adapt to come up with his own ideas that are very different from what other artists are offering. While creativity is a gift, it can also be nurtured. A good artist should release something new every single time to keep the audience coming back for more.

Besides that, a good artist should be aware of what the audience wants. Take time to know what your audience interests and make advancements from there. This helps to stick to a particular frame of work while making improvements on what exists. Well, occasionally you can switch just to surprise your audience, which is beneficial for the hype.

Aside from this, a good artist should have an infatuation for what he does. There is so little that can be done when there is no muse. A good artist has strong feelings for what he does. He will not give up for anything. On that note, a good artist has to have an inherent passion for what he does to ensure that the love never dies.

Furthermore, an artist should be business minded. Apart from pursuing a dream, art is a source of livelihood. For that reason, it should be approached with a high level of seriousness. A good artist can market his work and earn a living out of it. If an artist has another

full-time job he has set life on, this might interfere with his ability to burgeon in the niche. As a result, an artist should rely on one niche if he is to remain focused on what he truly wants in life.

A great artist must have a keen eye on a creating a masterpiece. It is one thing to come up with a good piece, but it is something else to create an acceptable work of art. Therefore, an artist should consider the audience. Nothing should be undervalued when it comes to quality.

Good artists spend most of their time with people who share the similar interests with the ones they have. Irrespective of the niche, surrounding yourself with negative energy will always bring down your attempts of flourishing.

Therefore, a good artist should know what he or she wants. Moreover, a great artist must be vigilant and ready to pursue what he wants in his career.

Nothing should hold your efforts back to improve on any success they have recently achieved.

Lastly, a good artist should be steadfast. There is no straight path in becoming a great artist. Perhaps the rise and fall is what makes success even sweeter. Resilience is just part of being a maestro.

There are many reasons art is important for us. Not only can it help us to evolve as a society and encourage creative thinking and problem solving, but it can also be a valuable asset to self-expression.

Do you want to be professional in drawing? Proceed reading this book full of drawing techniques. It will enlighten and help you to get motivated enough to pursue your dreams of changing your current style into something even more professional. With enough practice and technique, any and all of us can evolve our drawing to be impressive. If you want to feel confident expressing yourself artistically, then utilizing this book will help you to accumulate the skills you need to create.

Drawings can be of different types. An image can be drawn with colors as well as without colors. If you are a beginner then it is always better to start with black and white drawing. If you are capable of mastering the art of black and white drawing then you can surely begin color drawing.

Even though you have that natural talent given to you by our creator, you need to really polish your skills to make your work professional. I will outline some overall tricks to make your work outstanding.

1) First of all it is important to choose the right kind of pencil for drawing. If you have the tendency to choose hard pencils then make sure you get rid of this habit. Drawing pencils are usually available with grades. It is important to check the grades before you buy a pencil.

2) It is very essential to make sure that you always draw from very natural things and you also need to take care of the background. If you choose a model for drawing then make sure the background of the model gets equal importance.

3) You should first understand the drawing of black and white. With the help of the pencil sketches you will be capable of capturing the actual shades of drawing.

4) Also, you should update yourself with different and geometrical shapes. These shapes are usually present in almost all the images.

Chapter 1

Tools and Equipments

DISCERNING THE TYPE OF YOUR PENCIL

After having a thought of what you would like to express in your drawing, a pen or pencil is needed. Every project requires a foundation, and to start with as a beginner at drawing, you should discern the difference between the pencils. Not all pencils are created equal. To create something realistic and awe-inspiring, sometimes it takes different types of pencils to create a depth to the work that would be difficult to accomplish otherwise.

For example, using a very dark pencil can provide a depth to a shadow that might make your picture pop right out of the page.

These pencils are used by professionals for good reason; they make the hardest part about creating a realistic drawing that much easier to accomplish.

By merely changing the angle at which the pencil is held, the breadth and softness of the line changes dramatically.

It's not without good reason that the pencil is the default artists' tool. Whatever materials artists' use, whatever techniques they employ, pencils are never far from hand. They are cheap and versatile, sensitive and robust, perfect for under drawing, rough studies and work in combination with most other media.

It's well worth splashing out on a few artists' quality pencils. They are graded from H (hard) to B (black) with a number prefix indicating the

degree of hardness or blackness.

The Eraser

An eraser is another vital part of your kit. Erasing mistakes and rough guidelines is an important part of the drawing process. There are many varieties on the market, but they all do essentially the same job.

Sharpening

A sharp knife or scalpel is essential for fashioning pencil points. Pencils will ideally be sharpened to reveal a good length of lead, unlike the uniform point produced by a pencil sharpener. Keep the blade at an acute angle to the pencil and always sharpen away from your body.

The Paper

For pencil sketches, a cheap spiral-bound sketchpad, A4 or preferably A3, would be good, but virtually any paper will do. For more advanced techniques, the grade and type of paper is more important, but need not be expensive if bought by the sheet.

EXERCISE TO GET ACQUAINTED WITH DRAWING PENCILS

A great exercise that you can do to help get yourself used to using the different types of drawing pencils is to sit down and take out a piece of paper and a wide range of the pencils. Pick them up, starting with the lightest, and with little to no pressure on the pencils, shade in an area of your paper. Make sure to start with the next number in the line, or the closest to it that you have, and shade with that one. Do the same thing down the line. You should ensure that each new pencil line is met with the last one so that you can see the difference in the shades for yourself.

This exercise will help to familiarize you with the different pencil gradients that are used by most common and professional artists today.

These drawing pencils can add a depth and richness to your work. Fortunately, these pencils are easily within arm's reach, and can quickly aid you into changing the quality of your pencil drawings in a matter of seconds.

SOME OF THE BASIC DRAWING TECHNIQUES

In this chapter, we are going to go through a little bit of tricks, methods and techniques involved in drawing. More of drawing techniques will be discussed into details in chapter 4. There is more to drawing than putting pencil to paper. Hatching, cross-hatching, stippling, scumbling, back and forth stroke and coming up with a clear outline are crucial techniques of drawing that every artist should get familiar with. These techniques give your image life and allow the audience mind to wonder. In that case, a good artist should be inclined to follow all these techniques to the latter.

Creating an outline for your drawing is essential. Any complete drawing has to have two outlines, with the first being lighter than the next. A lighter outline is necessary when creating basic shapes that make up the image. While a heavy outline may be used to make up the edges of your drawing. The technique is simple; do not press your pencil too hard on your paper.

You do not want to make it too difficult to erase your image when the image does not come out the way you want. Using different types of pencils, you can come up with a variety of lines. On the other hand, you can also come up with various types of line values and thickness depending on the way you hold the pencil. Using the sides of your pencil will definitely get thicker lines, whereas when you use the front part of your pencil you will get thin lines.

The second techniques in drawing are hatching and crosshatching. For the most part, hatching technique is used to offer a shading effect on

your object.

Preferably, the lines should be drawn following one direction to define them better. On the other hand, crosshatching makes your image look more real. To come up with crosshatching line, first draw hatching lines heading in one direction. Then cross over these lines in the opposite direction.

Another handy technique you can apply is the circular technique. This technique is particularly important when it comes to shading of your image. In that case, you have to move your pencil in a swirling motion to keep the swirls and circles as close together as you can.

You can also make your image look realistic by adding smooth shading lines.

These lines can be created in a manner of ways. First, you can use the side of your pencil to create smooth strokes that are close together. Start with a harder pencil as you move on to a softer one. Do not separate your lines too much since that will only make your image have a rough look.

It takes time to become better in drawing. The techniques might seem simple but they are really a painstaking procedure. Master each step as you advance from a beginner to get a chance to burgeon as an artist. Be yourself as an artist.

Do not follow trends that are not you. Do not be scared to think outside the box since you will only lock yourself in ideas that have already been explored.

Come up with a trend and let it guide other artists to come up with their own style.

Whereas holding a pencil in your writing grip allows you control of small movements from the fingers, for drawing, most movements will be made from the wrist, elbow and shoulder. Different grips will free

your pencil to make a full range of strokes, with that all-important element of confidence. Picture to be included

This is a general-purpose grip which is especially good for mapping out faint under drawing and for long sweeping curves. The pencil is held loosely about halfway along its shaft, allowing for varied pressure. Picture to be included

Much like a typical writing grip but with the pencil more upright, this grip is good for fine detailed work or for drawing in a small sketchbook.

With the blunt end of the pencil tucked into the palm, this grip is good for bold, angular mark making and heavy shading. Picture to be included

Held at the tips of the fingers and thumb, the pencil can produce very subtle lines and shading. Picture to be included.

Chapter 2

Have The Know How Of Light And Shadow

As a beginner at drawing, Understanding light is one of the biggest challenges. Without a proper understanding of light, our pictures are unbelievable and lack the glow of life that characterizes all great art. However, if an artist is able to master the elements of light and lighting, then she/he will be able to create unique and stunning pieces of art that can leave the audience around them in awe.

We tend to take light for granted, because it is everywhere and fairly easy to come by. However, many of us are able to break down the source of light simply by looking at the shadows and lightness in a picture or on an object. Discovering the source of light is the first important step in bringing your pictures to life, because without it, it is impossible to add any depth to the pictures we create.

Something important to keep in mind is that no matter what we are drawing, if we want it to look realistic we have to assign a light source. If you want the light source to be directly above your subject, then the shading and lighting will be much different than if it were to the left or to the right of the subject in your picture. Every piece of art needs a source of light assigned to it, even if the viewer cannot visibly recognize that the light source is coming from the area where you have chosen for it to be. You don't have to see the source of light to know that it is there. It is easy to assume that the object or subject in your picture is affected by light. If it wasn't then your entire portrait would just be dark.

If it is difficult for you to find the light source of an object, one simple way you can remedy this is by looking instead for the shadow. The shadows are the areas where no light is received by the object, and this is generally caused by a blockage of the light. Shadows, unless your object is being hit head on by an overhead light, are usually found opposite the light source. If you study an object, then you may find this to be the case.

It can take many years to fully understand the nature of light, but once you do, it will change the way you draw forever. The quality of your pictures will improve immensely, and nothing will be too complicated for you to portray. Of course, certain techniques can help to make this portrayal easier than others, and you will have to experiment with many different techniques to discover the ones that work the best for you. This is all part of the fun of learning and drawing, and once you get the basic techniques down, you will feel more empowered than ever when it comes to creating a world of your choice on the canvas of your choosing.

Light is a complicated matter, and it is usually classified using several sub-categories. With light always comes the effect of light as well, and without them, you would not know that it was light. Essentially there are variations of shadows that help us to determine where the light source is coming from, and other aspects of light, such as where it is reflected and the halftones that are cast off the direct source of light. Essentially it can be broken down into these categories:

Reflected Light

The reflected light in your work is found just under the core shadow, and has similar halftones to the area just around the part where the light is striking directly. It is the area of the object where the light is reflected and not directs, but it is still lit up because of the center light.

Occlusion Shadow

The occlusion shadow is found at the bottom of the object, directly where it is sitting against the background or surface it is resting on. The Occlusion shadow is the darkest area of the drawing, and serves to provide the impression that your object is three dimensional. The depth the Occlusion shadow adds to any drawing is highly important, and if you neglect to put it in, you may not end up happy with the end result. The Occlusion shadow is generally very thin, and you shouldn't be afraid to push the boundaries and go as dark as you can with it.

Center Light

The center light is where the light directly hits an object. In a drawing, this is going to be the lightest area in the picture. The area will be illuminated the most because it is where the light is directly falling.

Highlight

The highlight is just off the side of the center light. It is pure white and is caused by the directness of the light striking the object. If, for example, you have ever looked at a manga drawing or watched an anime, you will see white circles drawn in the eyes to make them look more realistic. These circles are meant to be highlights, and the highlights add depth to the drawing and provide insight as to the location of the light source in the drawing.

Halftones

Halftones are the area of the object where the light is beginning to dissipate. It provides the drawing depth that would not be there otherwise. It is a gradual darkening of the shadows, and is generally best portrayed using a gradient.

Core shadow

The core shadow is present in just about every image where light is striking an object directly. The light source will create a shadow just

opposite where it strikes, and the core shadow is generally found in the halfway point between the light source and the shadow that is cast from the object and the reflected light reaching the rest of the object.

Chapter 3

Breaking Objects to Base Shapes

USE OF BASE SHAPES TO COME UP WITH REAL OBJECT

Basically, using base shapes in drawing is a way of breaking down your subject into its basic geometric shapes so that you will be able to get a basic handle on the proportions and dimensions of your subject of choice. Breaking things down into base shapes is something that everybody can do, no matter what level of expertise they have. Even if you lack any and all experience with drawing, using base shapes can simplify even the most complicated of subjects so that you can begin to draw them with confidence and skill.

Base shapes are probably most commonly seen in illustration and animation, for example, when people or animals are being drawn. The base shapes of the face are broken down to circles and lines, helping beginner artists to truly get a grasp on the subject matter at hand and give them a sense of the way things look and translate onto paper. Art is an act of intense observation, so don't be discouraged if it takes some time to figure out which base shapes to use. In fact, it is very good to take your time with observation, because this means that your work will have more depth and breadth in the long run.

Pinpointing base shapes is actually very entertaining. If, for example, you wanted to draw a computer, you would be able to break it down into a couple of basic base shapes. The screen would most likely be a square, the keyboard would be a rectangle, and the mouse would be an oval. Arranging these very simple shapes in the right areas of the page; helps to give you the distinct impression of a work in progress. You

can break down any subject into a shape or a series of shapes. Even the human body can be broken down into a series of ovals and triangles. If you look closely enough, there is a base shape behind everything, and discovering it and putting it down onto paper is the first step beginners should take in creating a new masterpiece.

Just as every great novel usually starts with an outline, so every great work of art starts with base shapes. It is the easiest way to begin any new project, and a fast way for us to get our ideas accurately conveyed onto a page where we are free to fill in the blank spaces with our own ideas and details and techniques. It is just the basic outline of a great piece of art.

It is important to remember when you are creating your base shapes use a light amount of pressure and a light pencil. These rough outlines can be easily manipulated to create a piece of art that jumps off the paper but, if you make your foundation lines too dark, it can damage the integrity of the whole project.

This can be disastrous for any artist and their self-esteem, so you should always try to do yourself a favor and start out light enough that if you erase your line, there is barely any way of knowing that the line was ever there.

You should never be afraid of erasing when you are creating art. Sometimes it can even become its own technique. However, if you have to erase a lot, it can become discouraging. This is why it is very important to start out with the lightest pressure you possibly can. It can really lower a beginning artist's morale to make mistakes that are difficult to correct. But don't beat yourself up for making mistakes; sometimes they make things even better.

EXERCISE TO UTILIZE BASE SHAPES

A basic exercise you can do using base shapes is to take a look around the room that you are in and open your sketchbook. Break everything in the room down into its base shapes. If there is a person in the room, you can even break them down into base shapes.

Dissect the different areas of the body into different shapes. For example, while the head is generally a round oval shape, the neck can be seen as a smaller circle, and the torso a triangle. Fingers and other limbs can be elongated ovals held together by circular joints. The desk this person may be sitting at can then be broken down into rectangles and ovals as well, or squares and rectangles. You can draw an entire room in base shapes.

Something you should keep in mind while doing this exercise is to try not to put too much pressure on the pencil you are using. Do your best to make your base shapes light and malleable, so that you can ultimately do your best to add onto them and build them into a more three dimensional piece of art that can pop right to life before your eyes.

Chapter 4

Drawing techniques

SKETCHING TECHNIQUES

This is a continuation of chapter one, and now you are familiar with terms such as line, hatching, crosshatching, and stipple or stippling will. All these terms will be much discussed and illustrated to help you understand each and every technique used while drawing. These terms refer to the ways that ink is applied to the paper in order to suggest shapes, various tones, textures, and visual effects such as volume and distance.

Line defines contour and is an important design element in itself. This will be illustrated in the figure below.

Tone is important in rendering the solidity of form. Tone is simply shading that creates a contrast with the white of the paper. Tone involves a gray scale from almost white to black.

These are several of the ways to use ink line work to render subject matter.

Freehand Pen Techniques

Technique and style refer to the particular ways that you use the pen to produce your drawing. In executing any particular composition, there are many techniques to choose from. Below, we are going to look at a particular picture with the same subject. The subject is drawn using five different techniques. Although line is a very important drawing element, it is not always necessary to use line in a drawing if the edges

and form of the subject can be expressed with tone alone. A and E show sketches completed with no use of line whatever to assist in indicating the edges of the subject. D shows a minimal use of line; B, a maximum use of line. Note the softness of the subject in A and E, where there are no lines as such. The use of a finer pen allows development of finer details. The coarse pen used in C presents a bolder impression, but with this pen the drawing is accomplished more quickly, since a greater volume of ink is applied with each stroke. It takes much more time to complete a stipple drawing (E), since each motion of the pen applies only a minute amount of ink. None of these techniques is any "righter" than any other; they are simply different. If you draw often you will soon develop a style of your own based on these techniques.

PENCIL SKETCHING TECHNIQUES

Pencils and Paper

The way that graphite takes to paper is determined by the roughness of the paper surface. A very smooth surface does not hold the graphite well, so softer pencils are needed to make darker marks on paper with a very smooth surface.

Paper with a rough surface holds a good deal of graphite, so the softer pencils produce marks that are all about the same. To get lighter tones on paper with a rough surface, you must either press a kneaded eraser on the graphite from a soft pencil or use some of the harder pencils. The picture below shows how a range of pencils from 2H to 6B marked different kinds of paper. Note that the roughest papers, the 140 pound watercolor paper and the tracing vellum, show no perceptible difference between the HB, B, 3B, and 6B pencils. A range from 6H (very hard) to HB would be appropriate for these papers.

You can draw with just one pencil, producing a range of tones by

lightly touching the paper with the pencil to produce light tones and pressing heavily to produce dark ones, and by using the kneaded eraser. This will be illustrated in the picture below, where the same subject is shown drawn using six different paper and pencil combinations.

Pencil strokes take differently on different paper, depending on the roughness of the finish. You should make yourself a test chart like this one, with all of your drawing pencils on the types of paper you intend to use.

SKETCHING TIPS ON DRAWING DIFFERENT KIND OF OBJECTS

Trees

The first step and one that is simple would be to draw an ace of cards that in essence would be drawing three circles with a triangle as the base. This will act as your framework. It is the blue print that guides you to drawing your tree. The lines of the circles and triangle should be as faint as possible. You will then be required to sketch out the branches and the trunk. The trunk will follow the line of the triangle while the branches will occupy the circles. Next would be to sketch the outline of the branches. At this point, some branches may have to be covered.

The sunlight will then have to be brought in. decide on which side you want the sun to be situated. That would mean that the opposite side of the tree will have to be shed with shadows of the trunk, branches and leaves. Drawing individual leaves will be too hectic and would look unreal. Going with the shadings is the best way to go about it. The bottom line where the trunk meets the ground has to be done away with as it looks like the trunk is just floating on top of the ground.

Rocks

The first step is to draw the outlines of your rock(s). We then draw the major shadows by use of lines. The lines help to curve the planes of the rock. These are the angled surfaces of a rock. They help in outlining the real volume of the rock. Cracks can also be used to show the planes. The next step would be to highlight the wedges of the rocks. When added, it gives more life to your rocks.

Cracks are always part of many rocks. They also help in showing the planes.

You only have to ensure that you change the angle of the crack whenever you move from one plane to the next.

The last step will include addition of texture. This can be done by making a combination of small scratches and dots. Depending on where you want your sunlight to be, you will have to deepen the shadows on the opposite side of the sun. The shadows are also to be added at the base of the rocks to give them weight. The texture in the shadow at the base is to indicate grass. With that, your drawing will be more than complete and looking awesome.

Animals

First things to be drawn before anything else are the guides for the body and the head. You will the follow with the facial guidelines. In this case we shall be drawing a puppy, therefore, you can outline its nose and finish up the head by adding the ears and some little bit of hair in between them. The big friendly eyes should follow next in addition to the nose and mouth. A happy pappy will be great. A sad one may turn out to be a headache. As for the body, you will start with the front legs and paws then move to the hind legs. Its curly tail will come in last among the features. You could add some bit of fur if you please.

By now you should have a complete puppy. Erasing of the guidelines

and making any necessary corrections will follow before you start thinking of giving it paint. That should be all. However, other animals may not be as easy as the puppy because they may come with more defined features. However, they all follow the same guideline. Difference in size does not mean that they have different approaches to drawing them. It may just take you more time to complete.

Automobiles

There are two methods you can use to draw car. You can either do free hand or use the grid method. In the free hand method, you may begin with the baseline then draw the wheels. Makes sure they are spaced correctly. The rooflines can then be made using large pencil strokes. The next step would be to outline the shadows of the door panels. In case you find it hard to draw curved lines you can simply take it one short and quick stroke at a time. Finish up with the bottom and the nose details.

With the grid method, all you have to do is draw a grid the size in length and height of the car you want to draw. You can then draw the car square by square till it is complete. From here you will have to erase the grid. Between the two methods, the free hand is easier and faster but the grid method is more accurate. You can now start shading the car. From the roof, the body, the wheels all the way to the interior. The outer edges should be made a little darker. The tyres should have a darker outer part and the rims a bit lighter. The shadow beneath the car should not miss.

People

Drawing people can pose a big challenge. The symmetry of the face and shape of the body can be very hard especially if you are still trying to sharpen your skills. The first thing to do would be to simplify a person's major shapes. If you are referencing from a picture, you can draw the shapes on the picture before you start sketching. Circling these parts such as the nose, eyes, cheeks, forehead, and the back head

is akin to breaking everything down. Once you outline the shapes that make up the structure of the face or body, you will have a better understanding of the proportions and distance between features.

When you start to sketch, you should start with the head going downwards.

You can simply start by drawing a shape that is similar to the head. You will then proceed to the neck. As for the shoulders, you can draw a line perpendicular to the base of the neck. Its distance should be about 2 to 3 head widths and followed by small circles at the end of the lines. Below them would be oval shapes that will form the upper arms. This goes on until when you have a full body after which you start sketching the individual's face and body. The shapes only act as your guideline

Chapter 5

Shading and gradients

Shading is one of the most difficult techniques to master by any artist. It makes all the difference between having a flat image versus one that stands out and looks as if it could be living and breathing, just captured and frozen in a single moment of time. Without proper shading techniques, our work can look very dull and plain, and lack the professional quality that most of us strive for in our work. It can be very difficult to make the time to perfect shading, but without a basic knowledge of shading, you may end up staying stuck at a beginner level. It takes time and patience to begin understanding shading, and this can be discouraging for many people who are impatient.

Unfortunately for these people, the only difference between you as a beginner and a professional artist is the time that they have put into their craft. It takes dedication to hone the act of observation and the techniques associated with creating a breathtaking piece of work, but if you are able to truly allow yourself the creative freedom that perfecting good shading techniques can award you. If you can stay dedicated to your craft and devote yourself to learning proper shading techniques, you will be able to go far as an artist with confidence and ease.

Fortunately, there are some easy ways to work with shading, and one of the ways is to get you acquainted with professional quality drawing pencils.

These can help you in your craft significantly, especially if you are just getting used to shading. It is important to keep in mind that shading

techniques often rely on light and shadow, the nuances of which are difficult to fully comprehend without proper instruction.

Exercise and Tips to Master Shading and Gradients

To begin learning how to shade, you will have to begin with a simple line drawing. You can choose anything, but to start out with, the simpler is probably the better. All you need to do at this point is get the idea about how shading works and how you can use different pressures with your pencils to create a different lightness or darkness on the page.

The various gradients of lightness and darkness that we find in a drawing are called values. In order to truly understand shading and values, one popular exercise for beginner artists is to create a value square. This is a way to measure the gradients that you have access to through your pencils, even if you have only an HB pencil, so that you can practice creating a gradient of light, almost white, to darkness, or black. Professional drawing pencils are an easy way to accomplish this, but it can be done with any single pencil, and it should be done this way to practice putting the right amount of pressure on your pencils to create the gradient that you want for a specific drawing.

Value squares are easy to make. First, take a ruler and make a large rectangle on your paper. Using your ruler, divide it into seven or more rectangles of equal size. Then, begin with the lightest value that you can create from your preferred pencil. The goal here is to begin getting a handle on the way your hands use your pencils to create lightness and darkness and to see which types of pressure and which values are best to use to blend different gradients.

The first rectangle in your value square should be completely white. The next one should be very late, but it should not be the way. You should use one of your pencils to shade in the rectangle as lightly as you possibly can. The next rectangles should be shaded in so that it appears somewhat darker than the rectangle before it. You will start to

see an appealing gradient forming in your value square. The third square should be even darker, heading toward the darker side. If it helps, you should make your last rectangle as dark as possible so that you know just how dire to start making your squares so that the blending process is easier and you understand the gradient as you go. This will empower you to make an even more accurate value square.

As you precede down the line of your value squares, make sure that your shading gets gradually darker and darker. You do not want it to be too stark in contrast, because the goal here is to create values that blend easily together and seem to naturally go from light to dark. Once you have your value squares set up, you can begin to apply these values to your projects. The line drawing that you did previously will now benefit from the added test that you are providing for it through your value squares.

You are going to look for where the light is coming from and begin to shade away from it. You can't do shading without understanding the light source. You will have to begin shading the lightest area first and steadily grow darker as you go further away from the light source. You will have to make sure that you are being careful to use your values gently so that they blend naturally together like they do in your value square.

If this doesn't seem to be working for you, you can always try again. You can draw as many value squares as you need to until you get it right. Shading is one of the most difficult parts about drawing, so if you don't get it right the first time it will not be a large surprise, or even that big of a problem. Everybody takes time to get used to applying the right pressure to their pencils and understanding the gradients that are required in a natural blending of light.

There are so many different types of shading out there that once you master your value squares and understanding your gradients, then you are probably going to really enjoy finding out which shading technique is the best for you.

In order to start expressing your own personal style of drawing, you will want to expose yourself to several different shading techniques so that you can begin to create the art of your own personal vision and standards.

Approaching art in a step-by-step manner is a great way for you to slowly get your feet wet and started dabbling in a field where all it takes to succeed is hard work and dedication to learning new techniques and never giving up. Although shading can be difficult, once you have mastered this you will be a better artist than most other people. It takes patience, but it's something that all of us can do if we are dedicated to elevating ourselves from beginner to professional quality.

CONCLUSION

When it comes to drawing, creativity is the key thing. However, being creative without the right skills to output these ideas would be useless. Any good artist has a firm foundational knowledge of all the sketching concepts. While covering these concepts in a single sitting would be next to impossible, heightening your skills by practicing on the most basic drawing tasks could be the very practice you need to get better by the day.

Remember that it is the most basic drawing skills and concepts that when put together result into something awesome and amazing. After mastering the basics, try applying your skills onto more complex drawing jobs.

www.ingramcontent.com/pod-product-compliance
Lightning Source LLC
Chambersburg PA
CBHW071834200526
45169CB00018B/1477